THE LIBRARY
COLBY JUNIOR COLLEGE

THE VIRGIN AND THE CHILD

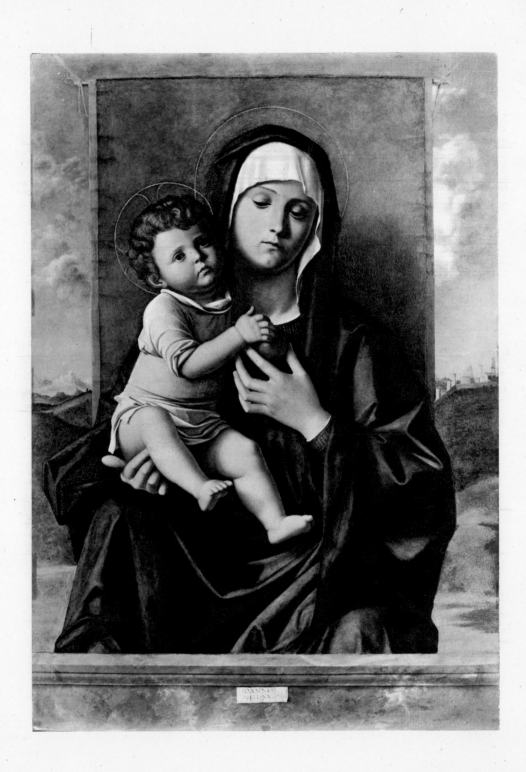

THE VIRGIN
AND THE CHILD

AN ANTHOLOGY
OF PAINTINGS AND POEMS

Edited by
ELIZABETH ROTHENSTEIN

LONDON: WILLIAM COLLINS SONS AND CO. LTD.
NEW YORK: CHARLES SCRIBNER'S SONS
1951

N
8070
R68

ALL RIGHTS RESERVED
PRINTED IN GREAT BRITAIN
COLLINS CLEAR-TYPE PRESS: LONDON AND GLASGOW

31912

Contents

CONTENTS

POEMS AND EXTRACTS

POEMS AND EXTRACTS

LIST OF PLATES

THE
IMMACULATE CONCEPTION

THE IMMACULATE CONCEPTION
 On loan to the National Gallery, London. Frere Collection
VELASQUEZ (1599–1660) *Spanish*

The picture belongs to Velasquez's early period. The young girl from whom it is painted, thought by some to be the painter's wife, is also the model for *The Adoration of the Kings*, which bears the date of 1619. Since the model for *The Immaculate Conception* is several years younger than she is in *The Adoration*, this painting may be dated at about 1617. It once hung in the sacristy of the Carmelite Church in Seville.

Text

I SAY THAT WE ARE WOUND

From *The Blessed Virgin compared to the Air we Breathe*, a poem written by Gerard Manley Hopkins at Stonyhurst in May 1883, to " hang up " in her honour " among the verse compositions in the tongues," as he wrote to Bridges.

THE LORD MADE ME HIS

From The Book of Proverbs, as translated by Mgr Ronald Knox. In the Roman Missal the passage makes the Lesson for the Mass of the Immaculate Conception. Its immediate reference, in the Old Testament, is to wisdom, but the application of wisdom literature to our Lady is traditional in the Roman liturgy.

Well knowen to God before the world began

★

I say that we are wound
With mercy round and round
As if with air: the same
Is Mary, more by name.
She, wild web, wondrous robe,
Mantles the guilty globe,
Since God has let dispense
Her prayers his providence:
Nay, more than almoner,
The sweet alms' self is her
And men are meant to share
Her life as life does air.

★

The Lord made me his when first he went about his work, at the birth of time, before his creation began. Long, long ago, before earth was fashioned, I held my course. Already I lay in the womb, when the depths were not yet in being, when no springs of water had yet broken; when I was born, the mountains had not yet sunk on their firm foundations, and there were no hills; not yet had he made the earth, or the rivers, or the solid framework of the world. I was there when he built the heavens, when he fenced in the waters with a vault inviolable, when he fixed the sky overhead, and levelled the fountain-springs of the deep. I was there when he enclosed the sea within its confines, forbidding the waters to transgress their assigned limits, when he poised the foundations of the world. I was there at his side, a master-workman, my delight increasing with each day, as I made play before him all the while; made play in this world of dust, with the sons of Adam for my play-fellows. Listen to me, then, you that are my sons, that follow, to your happiness, in the paths I shew you; listen to the teaching that will make you wise, instead of turning away from it. Blessed are they who listen to me, keep vigil, day by day, at my threshold, watching till I open my doors. The man who wins me, wins life, drinks deep of the Lord's favour.

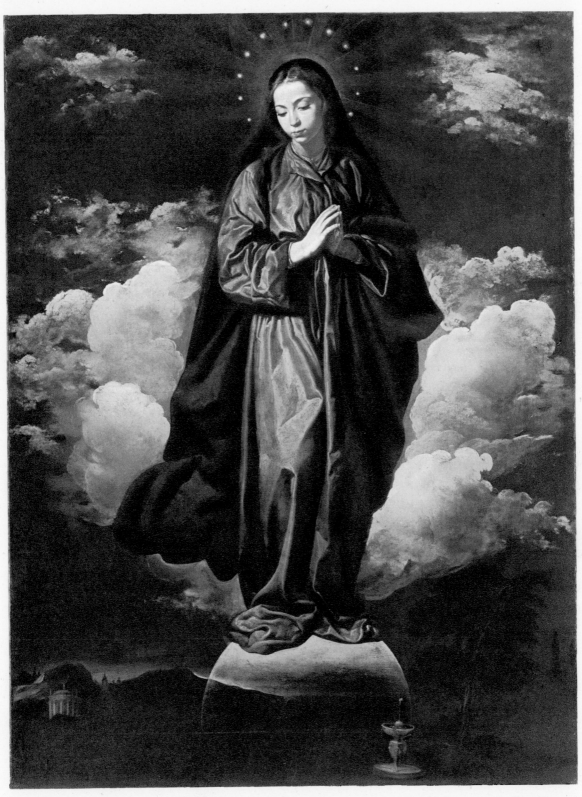

13

THE ANGEL
OF THE ANNUNCIATION

THE ANNUNCIATION (Detail) *National Gallery, London*
SCHOOL OF FRA ANGELICO, *Florentine*

This *Annunciation* is the work of a pupil of the Master's (Angelico died in
1455 at the age of sixty-eight), and is one of many replicas of the *Annunciation*
that Fra Angelico painted for the Church of San Domenico at Cortona
between 1414 and 1418. The Cortona composition was used again, under
the Master's supervision, in the still better known *Annunciation* painted in
the convent of San Marco *circa* 1440.

Text

FAIR ANGELS PAST BY

From the second book of Abraham Cowley's *Davideis*, first published in
1656, eleven years before his death.

" *God's Wife.* Though the word seems bold, I know no hurt in the
figure. And *Spouse* is not an *Heroical word.* The *Church* is called *Christ's
Spouse*, because whilst it is *Militant*, it is only as it were *Contracted*, not
Married, till it becomes *Triumphant*, but here is not the same reason." The
note is Cowley's own.

The angell seide ' Conceive thou schalt
Within thy body bright'

★

Fair *Angels* past by next in seemly bands,
All gilt, with gilded basquets in their hands.
Some as they went the blew-ey'd *violets* strew,
Some spotless *Lilies* in loose order threw.
Some did the way with full-blown *roses* spread;
Their smell divine and colour strangely red;
Not such as our dull gardens proudly wear,
Whom *weathers* taint, and winds *rude kisses* tear.
Such, I believe, was the first *Roses* hew,
Which at *God's* word in beauteous *Eden* grew.
Queen of the *Flowers*, which made that *Orchard* gay,
The morning blushes of the *Springs new Day*.
 With sober pace an heav'enly *Maid* walks in,
Her looks all fair; no *sign* of *Native sin*
Through her whole body writ; *Immod'erate Grace*
Spoke things far more then humane in her face.
It casts a dusky gloom o'er all the flow'rs;
And with *full beams* their *mingled Light* devours.
An *Angel* straight broke from a shining cloud,
And prest his wings, and with much rev'rence bow'd.
Again he bow'd, and grave approach he made,
And thus his sacred Message sweetly said:
 Hail, full of *Grace*, thee the whole world shall call
Above all *blest*; *Thee*, who shalt bless them all.
Thy *Virgin womb* in wondrous sort shall shroud
Jesus the God; (and then again he *bow'd*)
Conception the great *Spirit* shall breathe on thee;
Hail thou, who must *God's wife, God's mother* be!
With that, his seeming form to heav'n he rear'd;
She low obeisance made, and disappear'd.

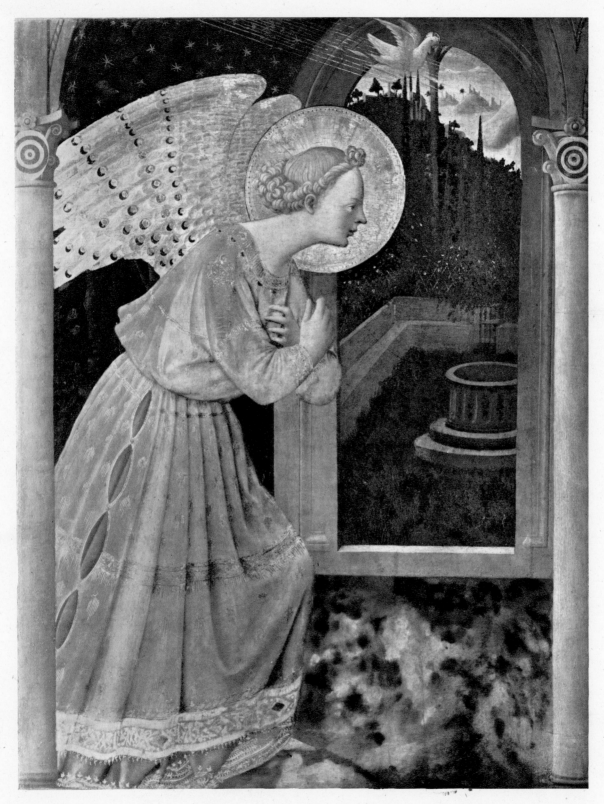

THE VIRGIN
OF THE ANNUNCIATION

THE ANNUNCIATION (Detail) *National Gallery, London*

FRA FILIPPO LIPPI (c. 1406–1469) *Florentine*

Filippo Lippi has little or nothing of the profound and pure spirituality of
the Dominican Fra Angelico. (Lippi was an orphan who was put into the
Carmelite Order and whose temperament led him into many complications.)
Nor is he an intellectual painter. But as Bernard Berenson once wrote,
" If attractiveness, and attractiveness of the best kind, sufficed to make a
great artist, then Filippo would be one of the greatest, greater perhaps than
any other Florentine before Leonardo." The extraordinary charm of his
work, his gaiety and grace and tenderness, and his interest in the people
about him, have made him one of the most popular of Florentine painters.

This *Annunciation*, painted for Cosimo de' Medici, was taken from the
Riccardi Palace at Florence.

Text

HERE IS THE SMALL BARE GARDEN

From a poem, *The Life of the Virgin*, by F. T. Prince, first published in
The Month, May 1949.

For in this rose conteinid was
Hevene and erthe in litel space

★

Here is the small bare garden,
 And the hollow sky, the dark tree.
We see the Virgin's mind.

This is the moment of arrested movement
 And the locution of the Angel,
The significance of the silence,
 And the soft flurry of silence,
When the music without notes
 Ceases, and on the silent air the words form
Slowly, the gold speech shining
 On the still air. Where the gold forms
Over her head a place of rays,
 In a pale robe
 She sits and prays
Under the low stone roof, the porch
 That would be the first cloister, in that purity
Wherein she imitated Your own purity, that charity
 Which went before and followed that same charity
Which drew You to her womb, in that humility
 Wherein she imitated Your humility.

The blue cloak rumpled on the floor
 Over her feet, she hesitates,
Leans forward,
And with soft open eyes
 And lips that move no longer
Merely
 Listens.

Tangled and sown with daisies,
 The stretch of delicate grasses
Running towards the step below her feet is bowed and
 ruffled,
 And carries on the backs of silvery waves
The breath brought by the Angel.

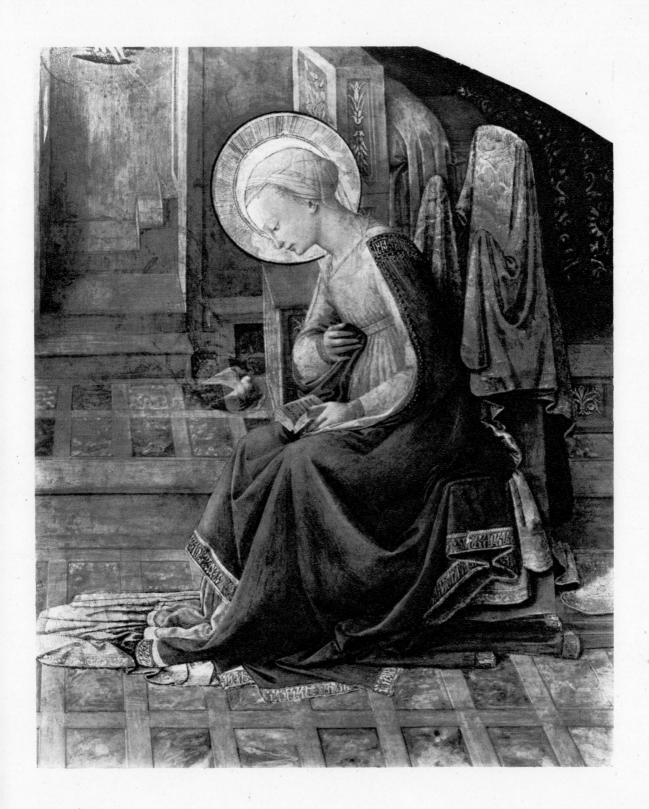

21

THE
VIRGIN OF NAZARETH

THE VIRGIN *National Gallery, London*
AFTER QUINTEN MASSYS (1465/6–1530) *Flemish*

Quinten (or Quentin) Massys (or Metsys) was born in Louvain and grew
up there, but in 1491 he is to be found at Antwerp, where he spent his
working life. Through Erasmus St Thomas More came to know and to
admire some of his work, and spoke of him as an artist who had brought
a new life to the older tradition of painting. And in fact something of
Leonardo's influence has been detected in his later work, "primitive"
painter though he remains. He was the leading artist of his time at Antwerp.

Text

THIS IS THAT BLESSED MARY

The first oil-painting that Dante Gabriel Rossetti attempted was begun
during the autumn of 1848 in Holman Hunt's studio, under his and Madox
Brown's supervision. Entitled *The Girlhood of Mary Virgin*, it is signed and
dated *Dante Gabriel Rossetti P R B* 1849. In this year Rossetti was twenty-
one years of age. His next picture was the better known *Ecce Ancilla Domini*,
signed and dated *D.G.R.* 1850. (Both pictures are now in the Tate Gallery,
London, and are reproduced in the Phaidon *Pre-Raphaelite Painters*, Plates
31 and 30.) It was in reference to them that about this same time he wrote
two sonnets, of which *This is that Blessed Mary* is the first. It refers directly
to the painting of 1849, though *She woke in her white bed* connects immedi-
ately with that of 1850. The sonnet is, of course, completely Pre-Raphaelite
in flavour.

SALVATION TO ALL THAT WILL IS NIGH

From John Donne's *Divine Poems*, composed sometime after 1610 and first
published a few years after his death in 1631.

Now shrinketh rose and lylie flour
That whilen ber that swete saviour

This is that blessed Mary, pre-elect
 God's Virgin. Gone is a great while, and she
 Dwelt young in Nazareth of Galilee.
Unto God's will she brought devout respect,
Profound simplicity of intellect,
 And supreme patience. From her mother's knee
 Faithful and hopeful; wise in charity;
Strong in grave peace; in pity circumspect.

So held she through her girlhood; as it were
 An angel-watered lily, that near God
 Grows and is quiet. Till, one dawn at home,
She woke in her white bed, and had no fear
 At all—yet wept till sunshine, and felt awed:
 Because the fulness of the time was come.

★

Salvation to all that will is nigh;
That All, which alwayes is All every where,
Which cannot sinne, and yet all sinnes must beare,
Which cannot die, yet cannot chuse but die,
Loe, faithfull Virgin, yeelds himselfe to lye
In prison, in thy wombe; and though he there
Can take no sinne, nor thou give, yet he will weare
Taken from thence, flesh, which deaths force may trie.
Ere by the spheares time was created, thou
Wast in his minde, who is thy Sonne, and Brother;
Whom thou conceiv'st, conceiv'd; yea thou art now
Thy Maker's maker, and thy Father's mother;
Thou hast light in darke; and shutst in little roome,
Immensity cloystered in thy deare wombe.

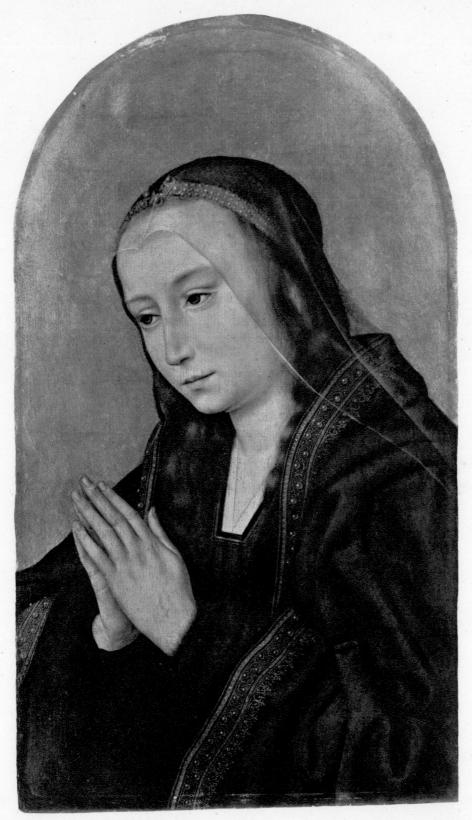

25

THE ANNUNCIATION

THE ANNUNCIATION
> *The National Gallery of Art, Washington. Kress Collection*

BALDOVINETTI (c. 1426–1499) *Florentine*

Alesso Baldovinetti served his apprenticeship with Fra Angelico. His work has none of his master's unique spirituality, but he had a fine sense of decorative simplicity, as is evident from his delight in line and surface pattern and by his predilection for the striking silhouette.

This picture, on wood (like the majority in this book), was probably painted between 1449 and 1454.

Text

UPON A DARKSOME NIGHT

The poem *The Dark Night* by St John of the Cross (1542–1591). He may have composed it in prison at Toledo, where in the night of December 2nd, 1577, he had been abducted by the Calced Carmelites and gaoled in their Monastery there. St John was from the beginning most closely connected with St Teresa of Avila's Discalced Reform of the Carmelites, and for a time there was bitter and sometimes violent hostility from the Unreformed. He was out of prison by March 1578. One of his works, *The Ascent of Mount Carmel*, written between 1578 and 1584/5, takes the form of a commentary upon this poem. Among the greatest of mystics, St John was, of course, a Carmelite.

The translation is by Professor Allison Peers.

This blissful floure
Sprang never bot in Marys boure

★

Upon a darksome night,
Kindling with love in flame of yearning keen
—O moment of delight!—
I went, by all unseen,
New-hush'd to rest the house where I had been.

Safe sped I through that night,
By the secret stair, disguisèd and unseen,
—O moment of delight!—
Wrapt in that night serene,
New-hush'd to rest the house where I had been.

O happy night and blest!
Secretly speeding, screen'd from mortal gaze,
Unseeing, on I prest,
Lit by no earthly rays,
Nay, only by heart's inmost fire ablaze.

'Twas that light guided me,
More surely than the noonday's brightest glare,
To the place where none would be
Save one that waited there—
Well knew I whom or ere I forth did fare.

O night that led'st me thus!
O night more winsome than the rising sun!
O night that madest us,
Lover and lov'd, as one,
Lover transform'd in lov'd, love's journey done.

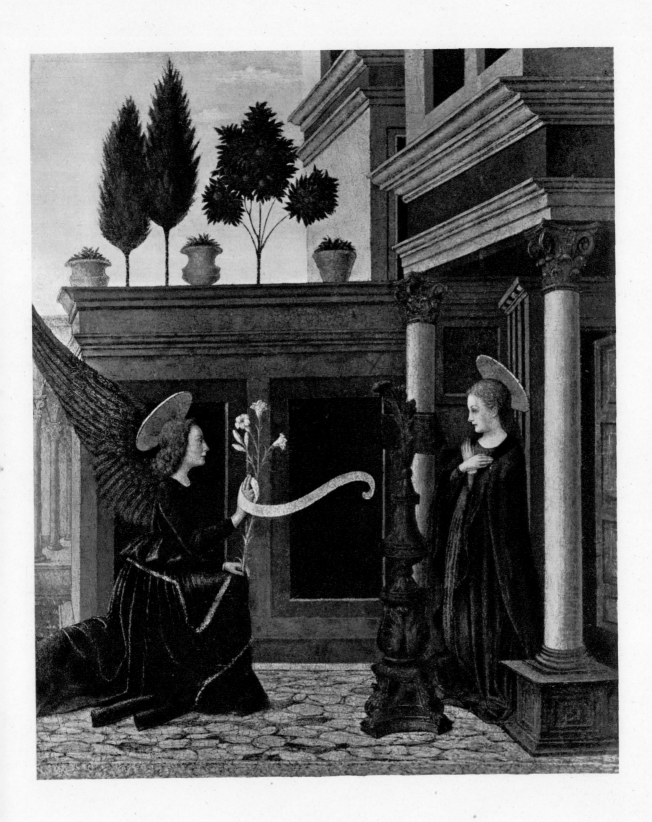

THE VISITATION

THE VISITATION OF THE VIRGIN TO ST ELIZABETH

National Gallery, London

STUDIO OF THE MASTER OF 1518, *Early Netherlandish*

The name *Master of 1518* is the name given by Friedlaender to a painter to whom he attributes many works of the Antwerp School of the early part of the 16th century.

Text

A MOTHER CAME TO MOULD

From Gerard Manley Hopkins, *The Blessed Virgin compared to the Air we Breathe*. See note on page 11.

THE VOICE OF MY BELOVED

From *The Song of Songs*, Douay version, 1609. In the Roman Missal the passage is the Lesson for the Mass of the Visitation. Mgr Ronald Knox suggests that it is the dream of a village girl, abducted to a king's palace, of her village lover. *The Song of Songs* has always been a much loved book in the Christian liturgy and in mystical writings.

As sunne schineth throw the glass
So Jhesu in his moder was

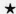

A mother came to mould
Those limbs like ours which are
What must make our daystar
Much dearer to mankind;
Whose glory bare would blind
Or less would win man's mind.
Through her we may see him
Made sweeter, not made dim,
And her hand leaves his light
Sifted to suit our sight.

★

The voice of my beloved! Behold, he cometh leaping upon the mountains, skipping over the hills. My beloved is like a roe, or a young hart. Behold, he standeth behind our wall, looking through the windows, looking through the lattices. Behold, my beloved speaketh to me: Arise, make haste, my love, my dove, my beautiful one, and come. For winter is now past; the rain is over and gone. The flowers have appeared in our land, the time of pruning is come; the voice of the turtle is heard in our land, the fig tree hath put forth her green figs, the vines in flower yield their sweet smell. Arise, my love, my beautiful one, and come; my dove in the clefts of the rock, in the hollow places of the wall, shew me thy face, let thy voice sound in my ears: for thy voice is sweet and thy face comely. Catch us the little foxes that destroy the vines; for our vineyard hath flourished. My beloved is mine, and I am his, who feedeth among the lilies, till the day break and the shadows retire. Return: be like, my beloved, to a roe, or to a young hart upon the mountains of Bether.

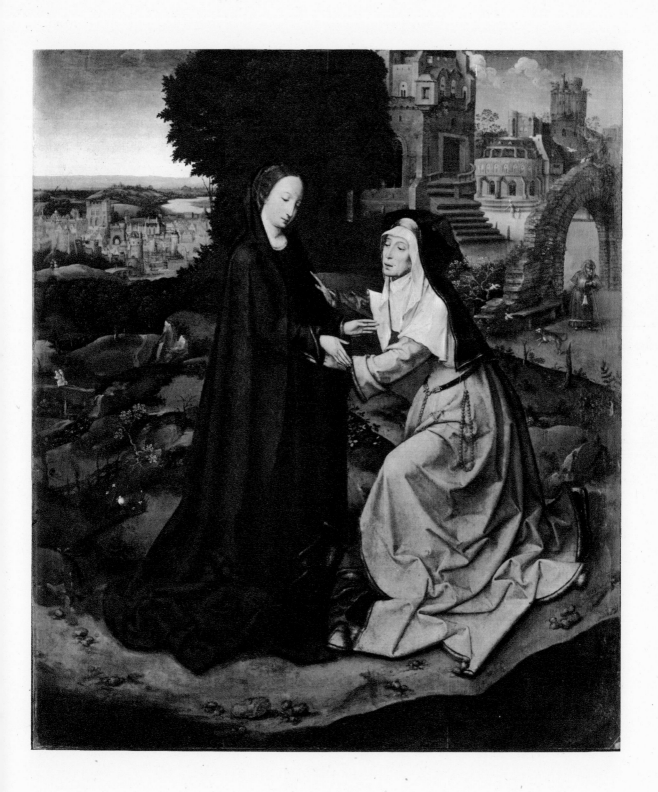

33

31912

FERNALD LIBRARY
COLBY JUNIOR COLLEGE
NEW LONDON, NEW HAMPSHIRE

OUR LADY
OF INTERCESSION

THE MADONNA OF THE GIRDLE (Detail)

National Gallery, London

MATTEO DI GIOVANNI (c. 1435–1495) *Sienese*

Matteo di Giovanni was trained in the studio of Lorenzo Vecchietta, who had himself, it would appear, worked under Sassetta. Decorative and two-dimensional as it mostly is, Sienese art in the Quattrocento has an æsthetic and religious character of its own that is quite different from the more exciting painting of contemporary Florence. Among other things, there is a difference of purpose. In Florence the painters looked forward and away from the preceding century; in Siena they looked back in reverence to their masters of the Trecento. Not that Florentine work was unknown in Siena, but it was imitated, in some respects, rather than assimilated.

We shall not understand the idiom of 15th century Sienese painting, as Mr. John Pope-Hennessy has written, " unless we remember that, to a quite unusual degree, religious literature in fifteenth century Siena perpetuated what we may loosely call the mysticism of the fourteenth century." The sense of the immanence of the supernatural that is at its most intense in Sassetta covers the whole of Sienese art.

The picture of which this plate is a detail was certainly finished by 1475; it dates possibly from about 1470.

Text

WHEREFOR IN LAUDE

The prayer of the Prioress in Geoffrey Chaucer's *Prologue* of *The Prioress's Tale*, written some time in the last twelve years of the 14th century. Chaucer died in 1400.

bote: welfare; *brenninge*: burning; *fadres sapience*: the Wisdom of the Father, i.e. Christ.

LADY, WHOSE SHRINE

This prayer makes the fourth movement of T. S. Eliot's *The Dry Salvages*, 1942.

This flour is faire and fresche of heue ;
It fades never, bot ever is new

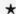

Wherfor in laude, as I best can or may,
Of thee, and of the whyte lily flour
Which that thee bar, and is a mayde alway,
To telle a storie I wol do my labour;
Not that I may encresen hir honour;
For she hir-self is honour, and the rote
Of bountee, next hir sone, and soules bote.—

O moder mayde! o mayde moder free!
O bush unbrent, brenninge in Moyses sighte,
That ravisedest doun fro the deitee,
Thurgh thyn humblesse, the goost that in th'alighte,
Of whos vertu, whan he thyn herte lighte,
Conceived was the fadres sapience,
Help me to telle it in thy reverence!

Lady! thy bountee, thy magnificence,
Thy vertu, and thy grete humilitee
Ther may no tonge expresse in no science;
For som-tyme, lady, er men praye to thee,
Thou goost biforn of thy benignitee,
And getest us the light, thurgh thy preyere,
To gyden us un-to thy sone so dere.

★

Lady, whose shrine stands on the promontory,
Pray for all those who are in ships, those
Whose business has to do with fish, and
Those concerned with every lawful traffic
And those who conduct them.

Repeat a prayer also on behalf of
Women who have seen their sons or husbands
Setting forth, and not returning:
Figlia del tuo figlio,
Queen of Heaven.

Also pray for those who were in ships, and
Ended their voyage on the sand, in the sea's lips
Or in the dark throat which will not reject them
Or wherever cannot reach them the sound of the sea bell's
Perpetual angelus.

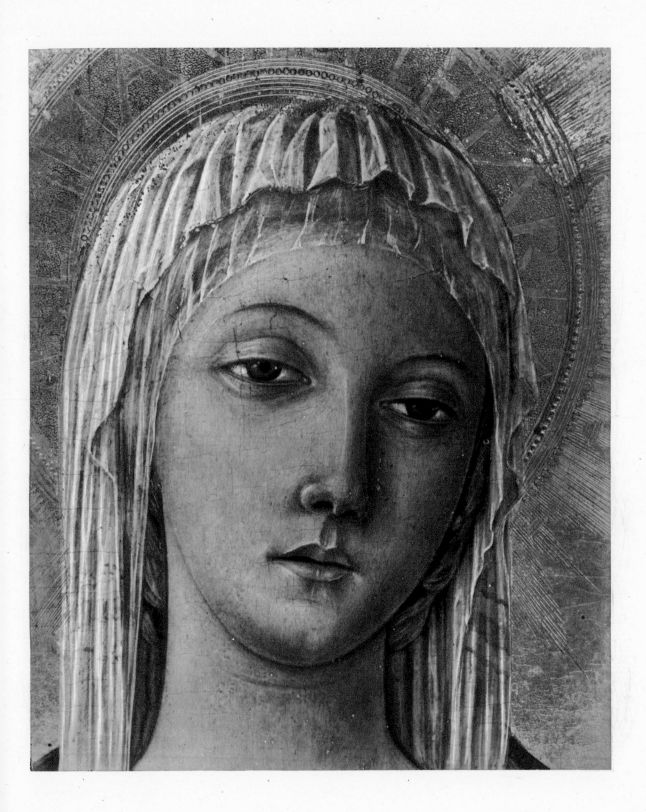

37

ANGELS
AT THE NATIVITY

THE ADORATION OF THE KINGS (Detail)

National Gallery, London

JAN GOSSAERT, *called* MABUSE (*active* 1503–1533) *Flemish*

Mabuse was already a mature painter when his name is first to be found, in 1503, on the roll of the painters' Guild at Antwerp. He worked in various small European courts.

" As usual in Epiphanies of the later fifteenth and earlier sixteenth centuries," wrote Mr. Martin Davies of the picture of which this is a detail, " the scene is a sumptuous ruin." The picture is datable between 1500 and 1515, and on the grounds that its style is more primitive than that of a characteristic Gossaert and has much that recalls Gerard David and Hugo van der Goes Mr. Davies would put it before the artist's Italian journey of 1508/9.

The Adoration was painted for the Abbey of St Adrian at Grammont.

Text

WHEN CHRIST WAS BORN

From British Museum MSS, to which is appended an MS note, " A Collection of Ancient Poems . . . dated ye 34 year of K. Hen. VI, 1456." The text is printed from Chambers and Sidgwick, *Early English Lyrics*.

RUN, SHEPHERDS, RUN

The Angels for the Nativity of Our Lord, by William Drummond (1585–1649) of Hawthornden, near Edinburgh, published in 1623.

Now angeles knelen to manes servis

★

When Crist was born of Mary free
In Bedlem in that faire cité,
Angelles song ever with mirth and glee
 In excelsis gloria.

Herdmen beheld thes angelles bright
To hem apperéd with gret light,
And seid ' Goddes sone is born this night.'
 In excelsis gloria.

This king is comen to save kinde,
In the scriptur as we finde;
Therefore this song have we in minde,
 In excelsis gloria.

Then, Lord, for thy gret grace,
Graunt us the bliss to see thy face,
Where we may sing to thy solas
 In excelsis gloria.

Run, shepherds, run where Bethlem blest appears,
We bring the best of news, be not dismayed,
A Saviour there is born more old than years,
Amidst heaven's rolling heights this earth who stayed.
In a poor cottage inned, a virgin maid
A weakling did him bear, who all upbears;
There is he, poorly swaddled, in manger laid,
To whom too narrow swaddlings are our spheres:
Run, shepherds, run, and solemnize his birth,
This is that night—no, day, grown great with bliss,
In which the power of Satan broken is;
In heaven be glory, peace upon the earth!
Thus singing, through the air the angels swam,
 And cope of stars re-echoèd the same.

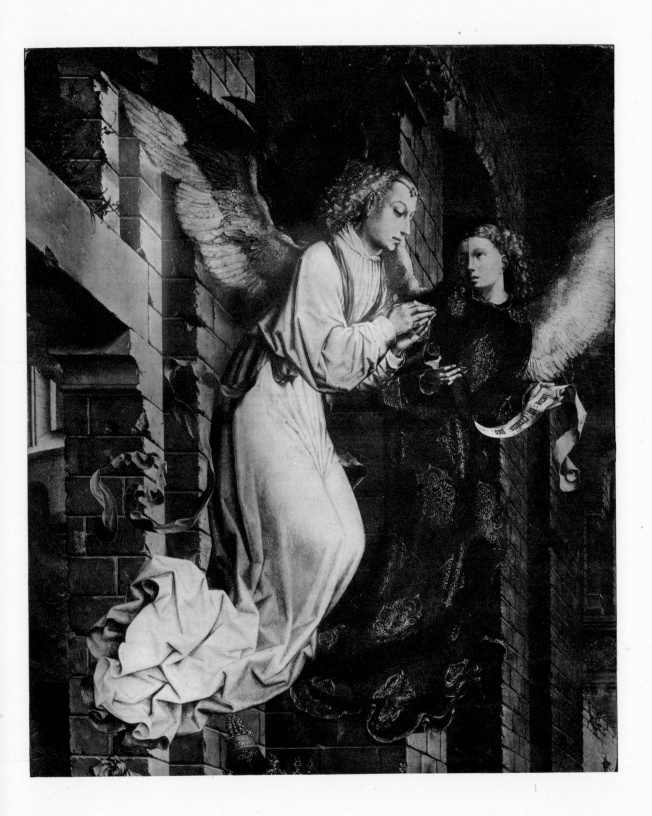

THE
NATIVITY AT NIGHT

THE NATIVITY AT NIGHT · *National Gallery, London*
ASCRIBED TO GEERTGEN TOT SINT JANS (Late 15th century)
Early Netherlandish

There appears to be no mention of this painter till more than a century after his death. His name means the little Gerard of the Brethren of St John, at Haarlem (he is sometimes called Geeraert van Haarlem), and, as far as can be ascertained, he was born at Leyden and died at about the age of twenty-eight. The approximate and inferred dates of his birth and death are 1465 and 1495.

As Mr. Martin Davies comments, this painting is an early, though not the earliest, treatment of the subject at night outside Italy.

Text

CHRIST TOOK OUR NATURE ON HIM

From Robert Herrick's *Noble Numbers*, first published in 1647.

THAT ON HER LAP

One of Richard Crashaw's "Divine Epigrams," *On the Blessed Virgin's Bashfulness*, published in *Steps to the Temple* in 1646, three years before his early death. Most of his poems were probably written in Rome.

AS I IN HOARY WINTER'S NIGHT

Robert Southwell's *The Burning Babe*. Southwell became a Jesuit in 1578 in his seventeenth year and returned as a priest to England in 1586, not quite five years after the execution of Edmund Campion. He was caught and arrested in 1592 and spent several weeks in the hands of the torturer Topcliffe, by whom he was put to shocking torture on ten occasions. He was afterwards removed to the Tower of London, where he spent three years in rigorous confinement. Eventually he was hanged, drawn and quartered at Tyburn, London, in 1595 at the age of thirty-four.

Speke softly, ye folk, for I am leyd aslepe

Christ took our nature on Him, not that He
'Bove all things lov'd it, for the puritie:
No, but He drest Him with our humane Trim,
Because our flesh stood most in need of Him.

That on her lap she casts her humble Eye,
'Tis the sweet pride of her Humility.
The faire starre is well fixt, for where, o where
Could she have fixt it on a fairer Spheare?
'Tis Heav'n, 'tis Heaven she sees, Heavens God there lyes.
She can see heaven, and ne're lift up her eyes:
This new Guest to her Eyes new Lawes hath given,
'Twas once *looke up*, 'tis now *looke down* to Heaven.

★

As I in hoary winter's night stood shivering in the snow,
Surprised I was with sudden heat which made my heart to glow;
And lifting up a fearful eye to view what fire was near,
A pretty Babe all burning bright did in the air appear;
Who, scorchèd with excessive heat, such floods of tears did shed,
As though his floods should quench his flames which with his
 tears were fed.
' Alas!' quoth he, ' but newly born in fiery heats I fry,
Yet none approach to warm their hearts or feel my fire but I.
My faultless breast the furnace is, the fuel wounding thorns;
Love is the fire, and sighs the smoke, the ashes shame and scorns;
The fuel justice layeth on, and mercy blows the coals;
The metal in this furnace wrought are men's defilèd souls:
For which, as now on fire I am to work them to their good,
So will I melt into a bath to wash them in my blood.'
With this he vanished out of sight and swiftly shrunk away,
And straight I callèd unto mind that it was Christmas day.

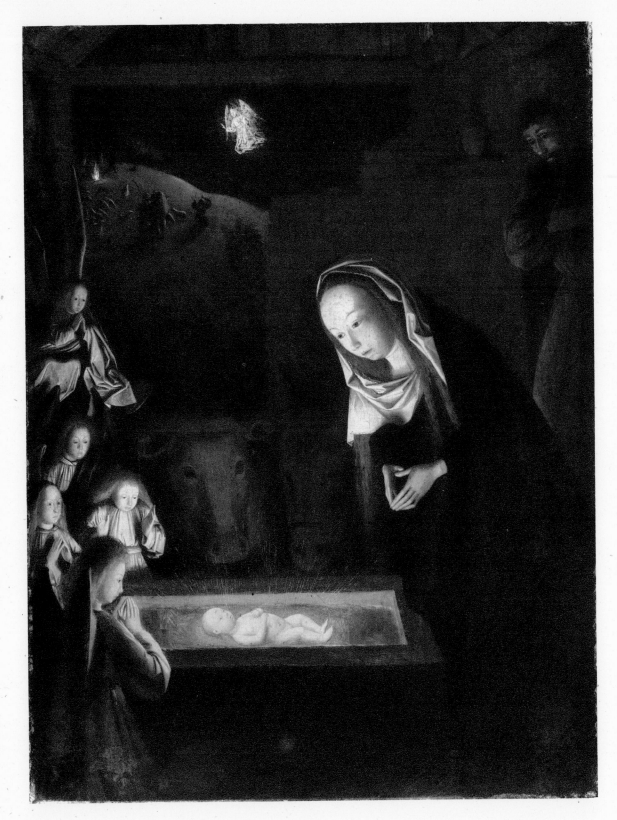

A SHEPHERD TO
WHOM THE ANGELS SANG

THE NATIVITY (Detail) National Gallery, London

GIROLAMO ROMANINO (c. 1485–1566?) School of Brescia

Born in Brescia, from 1510 onwards Romanino mostly lived there. In style he is akin to the Venetians, and like many painters of the time was much affected by Giorgione and by Giorgione's most gifted follower, Lorenzo Lotto.

The detail here reproduced is from the background of a *Nativity*, the central panel of a triptych that Romanino painted for the High Altar of Sant' Alessandro, Brescia.

Text

THE SHEPARD UPON A HILL

Stanzas selected from an anonymous 15th (?) century song preserved in a Balliol MS. The text is as printed by Chambers and Sidgwick, *Early English Lyrics.*

tabard: short coat; *tarbox*: the tar was used as a salve for sheep; *flagat*: bottle; *a litill braid*: a short time; *fairly*: marvellous.

There was mekel melody at that childes berthe

★

The shepard upon a hill he satt;
He had on him his tabard and his hat,
His tarbox, his pipe, and his flagat;
His name was called Joly Joly Wat,
 For he was a gud herdes boy.
 Ut hoy!
 For in his pipe he made so much joy.

The shepard upon a hill was laid;
His dog to his girdell was taid;
He had not slept but a litill braid,
But *Gloria in excelsis* was to him said.
 Ut hoy! *etc.*

The shepard said anon right,
' I will go see yon fairly sight,
Whereas the angel singeth on hight,
And the star that shineth so bright.'
 Ut hoy! *etc.*

Whan Wat to Bedlem cum was,
He swet, he had gone faster than a pace;
He found Jesu in a simpell place,
Betwen an ox, and an asse.
 Ut hoy! *etc.*

' Jesu, I offer to thee here my pipe,
My skirt, my tar-box, and my scripe;
Home to my felowes now will I skipe,
And also look unto my shepe.'
 Ut hoy! *etc.*

' Now may I well both hope and sing,
For I have been at Cristes bering;
Home to my felowes now will I fling.
Crist of heven to his bliss us bring!'
 Ut hoy! *etc.*

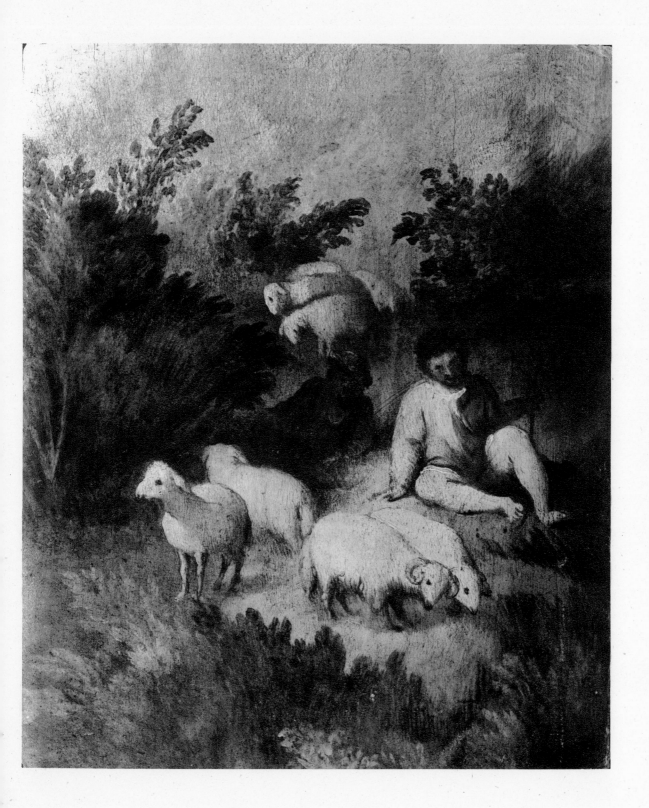

ANIMALS
ABOUT THE INFANT CHRIST

THE NATIVITY (Detail) *National Gallery, London*

BOTTICELLI (1444/5–1510) *Florentine*

Sandro Botticelli was about fourteen or fifteen years of age when, at some date near 1459, he entered the studio of Fra Filippo Lippi. His first authentically dated work is of 1470. His early painting is more lyrical in line and more sensuous than is his later, which shows a growing absorption in the moral and religious ideas that he is said to have derived from Savonarola.

On this *Nativity* there is an inscription that refers to the death of this preacher; the painting, then, would appear to be later than 1498.

Text

WE SAW HIM

Carol by Gerald Bullett.

I SAW A STABLE

A poem by Mary Elizabeth Coleridge (1861–1907). Her poetry was collected and published posthumously in 1907 and 1910.

CHRISTMAS EVE, AND TWELVE OF THE CLOCK

The Oxen by Thomas Hardy, who died in 1928 at the age of eighty-eight. Hardy was, of course, an atheist. *The Oxen* was published in a collection of Hardy's verse, *Moments of Vision*, in 1917.

The lord that boughte free and thrall
Is found in an asses stall

We saw him sleeping in his manger bed
And faltered feet and heart in holy dread,
Until we heard the maiden mother call:
' Come hither, sirs, he is so sweet and small.'

She was more fair than you have looked upon;
She was the moon, and he her little sun.
' O Lord,' we cried, ' have mercy on us all ';
But ' Ah,' said she, ' he is so sweet and small.'

Whereat the blessed beasts with one accord
Gave tongue to praise their little blessed Lord,
Oxen and asses singing in their stall:
' The king of kings, he is so sweet and small.'

I saw a stable, low and very bare,
 A little child in a manger.
The oxen knew Him, had Him in their care,
 To men He was a stranger.
The safety of the world was lying there,
 And the world's danger.

★

Christmas Eve, and twelve of the clock.
 ' Now they are all on their knees,'
An elder said as we sat in a flock
 By the embers in hearth-side ease.

We pictured the meek mild creatures where
 They dwelt in their strawy pen,
Nor did it occur to one of us there
 To doubt they were kneeling then.

So fair a fancy few would weave
 In these years! Yet, I feel,
If someone said on Christmas Eve,
 ' Come; see the oxen kneel

' In the lonely barton by yonder coomb
 Our chilhood used to know,'
I should go with him in the gloom,
 Hoping it might be so.

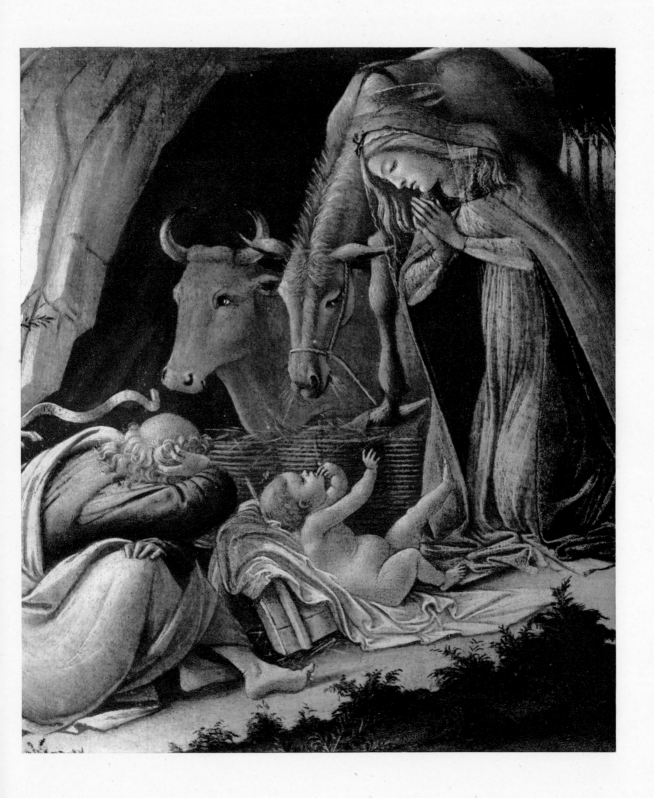

SINGING ANGELS

THE MADONNA OF THE GIRDLE (Detail)

National Gallery, London

MATTEO DI GIOVANNI (c. 1435–1465) *Sienese*

The detail here reproduced is from the same picture as is the detail reproduced on page 37.

Like his master, Vecchietta, Matteo di Giovanni had contacts with Florentine work. Indeed, about 1465, a few years before he painted the picture of which this plate gives a detail, he had been invited to his native place, Borgo San Sepolcro, to complete the side panels of an altar-piece that Piero della Francesca had designed some twenty-five years before. From Piero he doubtless learned something of his grasp of form. But these influences were in the long run superficial. Perhaps they were alien to the Sienese spirit. It is certainly not to be regretted that in the 15th century Sienese painting is " a backwater in the stream of artistic evolution." That these artists hardly questioned the traditions of their own predecessors is possibly owing to the piety and natural mysticism that were familiar to their city. To this piety, paying little heed to the scientific teaching of the Florentines, they were able to give an expression unusually spontaneous and tender.

Text

THE SHEPHERDS ON THE LAWN

Stanzas from John Milton's *Hymn on the Morning of Christ's Nativity*, composed in 1629; Milton was then twenty-one years of age.

Singe we all, for time it is
Mary hath born the flour-de-lyce

★

The shepherds on the lawn,
Or ere the point of dawn,
 Sat simply chatting in a rustick row;
Full little thought they than
That the mighty Pan
 Was kindly come to live with them below;
Perhaps their loves, or else their sheep,
Was all that did their silly thoughts so busy keep.

When such musick sweet
Their hearts and ears did greet,
 As never was by mortal fingers strook;
Divinely warbled voice
Answering their stringed noise,
 As all their souls in blissful rapture took:
The air such pleasure loth to lose,
With thousand echoes still prolongs each heav'nly close.

Such musick (as 'tis said)
Before was never made,
 But when of old the sons of morning sung;
While the Creator Great
His constellations set,
 And the well-balanc'd world on hinges hung,
And cast the dark foundations deep,
And bid the welt'ring waves their oozy channels keep.

Ring out ye crystal spheres,
Once bless our human ears
 (If ye have power to touch our senses so),
And let your silver chime
Move in melodious time;
 And let the base of Heav'n's deep organ blow;
And with your ninefold harmony
Make up full consort to th' angelick symphony.

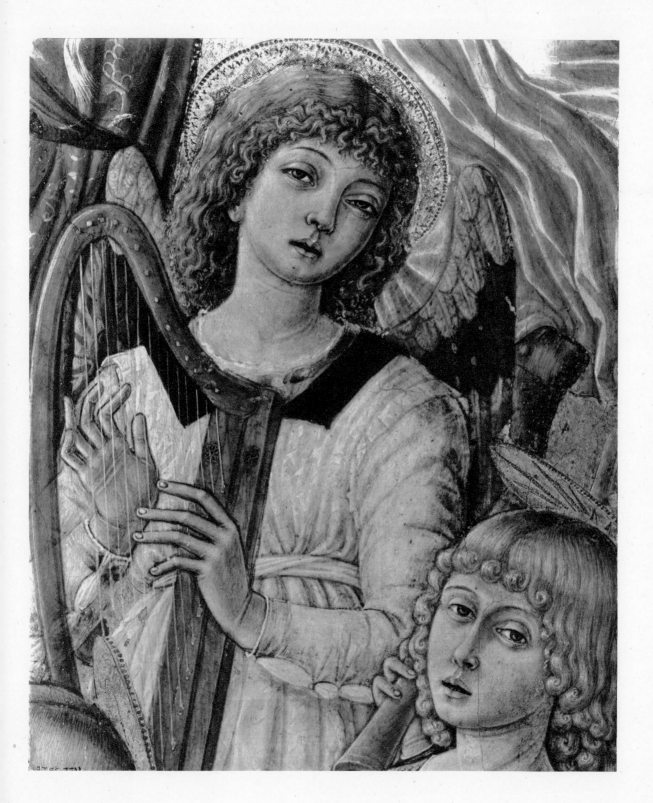

57

THE
MOTHER AND THE CHILD

VIRGIN AND CHILD *National Gallery, London*
STUDIO OF GERARD DAVID (c. 1460–1523) *Flemish*

Gerard David (see also the notes on pages 63 and 79) was a painter little
influenced by the Renaissance. Perhaps the most formative influence on
him was that of Hugo van der Goes, and this *Virgin and Child*, from his
studio, has been thought to betray the latter Master's influence. Of David
himself Sir Martin Conway wrote that " he was old-fashioned, but
genuinely so. He was constitutionally religious. One might imagine him
at home with the Brethren of the Common Life or any of the mystic
fellowships whose days of vitality were coming to an end when David was
born. The atmosphere of his pictures is like that of *The Imitation of Christ*."
The latter comment might, however, be more shrewdly made on Memling.

Text

I SING OF A MAIDEN

A lyric, perhaps the loveliest of all medieval songs, customarily ascribed
to the 15th century but quite probably earlier. It is preserved in a MS
that has been thought to be a minstrel's song-book. The text is that printed
in Chambers and Sidgwick, *Early English Lyrics*.
 makeles: matchless; *ches*: chose.

SPELL EVA BACK

From a poem, *The Virgin's Salutation*, by Robert Southwell (see note on
page 43). The notion that, tangle by tangle, our Lady unknotted all that
Eve had knotted and in every particular reversed her history, is not, of
course, a 16th century conceit or one peculiar to Southwell, but a traditional
and well-worn patristic theme to be found first explicitly and at some
length elaborated by St Irenaeus, who was born at Smyrna towards the
middle of the 2nd century and was martyred at Lyons in 202/3.

There is no rose of such vertu
As is the rose that bare Jhesu

★

I sing of a maiden
 That is makeles,
King of all kinges
 To her sone she ches.
He cam al so stille
 There his moder was,
As dew in Aprille
 That falleth on the grass.
He cam al so stille
 To his moderes bour,
As dew in Aprille
 That falleth on the flour.
He cam al so stille
 Ther his moder lay,
As dew in Aprille
 That falleth on the spray.
Moder and maiden
 Was never non but she;
Well may swich a lady
 Godes moder be.

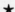

Spell Eva back and Ave shall you find;
The first began, the last reversed our harms:
An angel's witching words did Eva blind;
An angel's Ave disenchants the charms:
Death first by woman's weakness entered in;
In woman's virtue life doth now begin.

With haughty mind to Godhead man aspired,
And was by pride from place of pleasure chased;
With loving mind our manhood God desired,
And us by love in greater pleasure placed:
Man labouring to ascend procured our fall;
God yielding to descend cut off our thrall.

THE
ADORATION OF THE KINGS

THE ADORATION OF THE KINGS (Detail)

National Gallery, London

GERARD DAVID (c. 1460–1523) *Flemish*

Born probably near Utrecht, David spent most of his life in Bruges. He was especially affected by Hugo van der Goes, whose style was at once both deeply religious, even mystical, and popular. Both artists possessed a gentle and lyrical freshness that gave to their religious work something of the grave and youthful poetry of Fra Filippo Lippi.

This *Adoration* is a panel from an altar-piece.

Text

I THOUGHT, AT FIRST

A speech from a modern play about the Magi, or, rather, " the fourth wise man," Christopher Hassall's *Christ's Comet*, 1937, Act II, Scene 2.

Of alle lordis he is lord
Of alle kinges king

★

I thought, at first, our guide of moving fire
Would bring us to the cradle of a soldier
Born to discomfort Rome, but now a voice
Summons my erring heart. The rubied crown
I had intended for his brow, shall be
Exchanged for coin, and doled among the poor.
The treasure-box of stones, the Tyrian gowns
I shall not offer, nor presume to meet
His face, until the altar of my soul
Be truly consecrated to his service.
He sets no store by sleights and stratagems,
By streets of military tents, by horses
Caparisoned for death as for a tourney.
The Emperor's portrait on a silver token
Is not his kind of money. He loves not wine
Nor infinite variety of wardrobes,
But acts of brotherhood obscurely done,
Hot arduous days with harvest at the close,
The unrusting riches of a mind unsoiled.
What then am I? a thing of iron and ashes!
By Heaven, I'll fight no more Italian bones,
But to my own rebellious heart lay siege
And starve the pride out, that my Captain
May enter by the scarlet gate to find
A city cleansed, and humble to his law.
You look amazed. Was it not prophesied
By Balaam, son of Peor, that a star
Should rise from Jacob, and that his name should be
The Prince of Peace? I tell you this same prince
Shall found an empire and a capital town
That, in comparison, shall make your Rome
A bandit's bivouac, and those who love him
Shall far outnumber the Numidian sand.

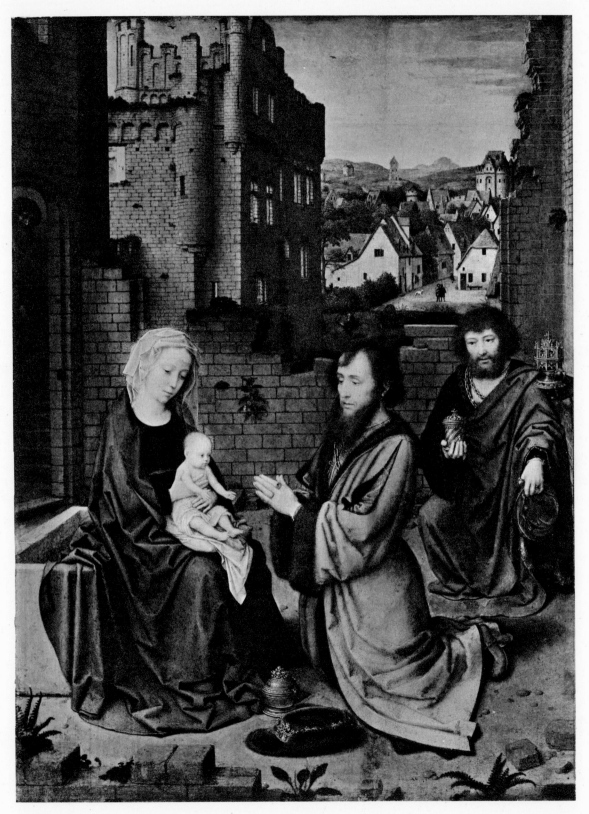

THE PRESENTATION IN
THE TEMPLE

THE PRESENTATION IN THE TEMPLE *Gulbenkian Collection*
STEFAN LOCHNER (c. 1400–1451) *School of Cologne*

Born in Meersburg am Bodensee, Lochner settled in Cologne about 1430.
He has been called the Fra Angelico of the North. The quality of his simple
and moving piety is one of several points of resemblance.

Text

LORD, THE ROMAN HYACINTHS
T. S. Eliot's *A Song for Simeon*, 1928.

Then, Lord, for thy gret grace,
Graunt us the bliss to see thy face

★

Lord, the Roman hyacinths are blooming in bowls and
The winter sun creeps by the snow hills;
The stubborn season has made stand.
My life is light, waiting for the death wind,
Like a feather on the back of my hand.
Dust in sunlight and memory in corners
Wait for the wind that chills towards the dead land.

 Grant us thy peace.
I have walked many years in this city,
Kept faith and fast, provided for the poor,
Have given and taken honour and ease.
There went never any rejected from my door.
Who shall remember my house, where shall live my children's
 children
When the time of sorrow is come?
They will take to the goat's path, and the fox's home,
Fleeing from the foreign faces and the foreign swords.

 Before the time of cords and scourges and lamentation
Grant us thy peace.
Before the stations of the mountain of desolation,
Before the certain hour of maternal sorrow,
Now at this birth season of decease,
Let the Infant, the still unspeaking and unspoken Word,
Grant Israel's consolation
 To one who has eighty years and no to-morrow.

 According to thy word.
They shall praise Thee and suffer in every generation
With glory and derision,
Light upon light, mounting the saints' stair.
Not for me the martyrdom, the ecstasy of thought and prayer,
Not for me the ultimate vision.
Grant me thy peace.
(And a sword shall pierce thy heart,
Thine also).
I am tired with my own life and the lives of those after me,
I am dying in my own death and the deaths of those after me.
Let thy servant depart,
Having seen thy salvation.

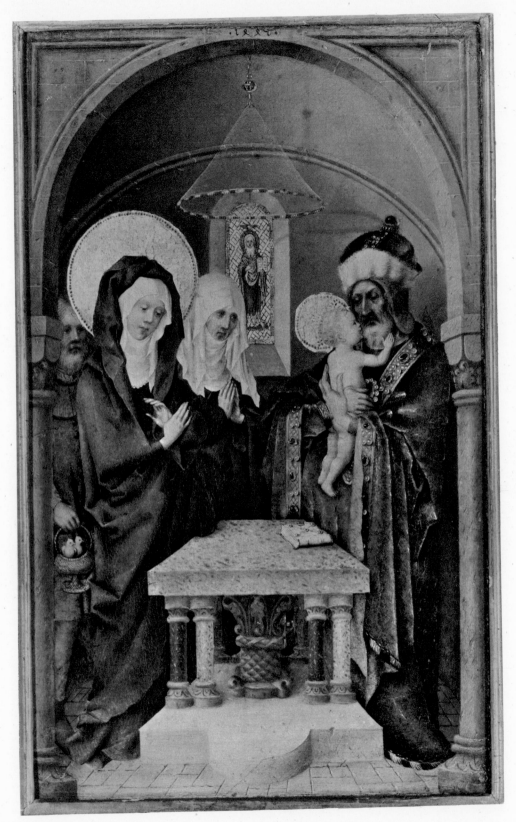

69

THE INCARNATE WORD

MADONNA AND CHILD WITH SAINTS (Detail)

National Gallery, London

Ascribed to Ercole Grandi (1465?–1535) *School of Ferrara*

Ercole Grandi, who is said to have been born in Ferrara, worked under Ercole Roberti and was an assistant of Lorenzo Costa. Indeed his work is still not clearly distinguished from theirs.

The painting of which this plate reproduces a detail was originally in the Church of the Concezione at Ferrara. Listed in the National Gallery's Catalogue as the work of Grandi, it has recently been analysed in the Gallery's laboratory. The X-ray shadowgraphs reveal that more than one Master worked on it. It was in fact begun by one of the Maineri brothers (late 15th century painters who worked rather in the Gothic tradition), and was continued by Lorenzo Costa.

Text

JESUS TO CAST ONE THOUGHT UPON

An undated and recently discovered translation by Gerard Manley Hopkins of an old Latin hymn, the *Jesu Dulcis Memoria*, that has been variously ascribed. (St Bernard of Clairvaux is the usual claimant, but even Jacopone da Todi has been suggested.)

Honour be withouten ende
To hym that fro the hevyne discende

★

Jesus to cast one thought upon
Makes gladness after He is gone,
But more than honey and honeycomb
Is to come near and take Him home.

Song never was so sweet in ear,
Word never was such news to hear,
Thought half so sweet there is not one
As Jesus God the Father's Son.

Jesu, their hope who go astray,
So kind to those who ask the way,
So good to those who look for Thee,
To those who find what must Thou be?

To speak of that no tongue will do
Nor letters suit to spell it true;
But they can guess who have tasted of
What Jesus is and what is love.

Jesu, a springing well Thou art,
Daylight to head and treat to heart,
And matched with Thee there's nothing glad
That can be wished or can be had.

Wish us good morning when we wake
And light us, Lord, with Thy day-break.
Beat from our brains the thicky night
And fill the world up with delight.

Be our delight, O Jesu, now
As by and by our prize art Thou,
And grant our glorying may be
World without end alone in Thee.

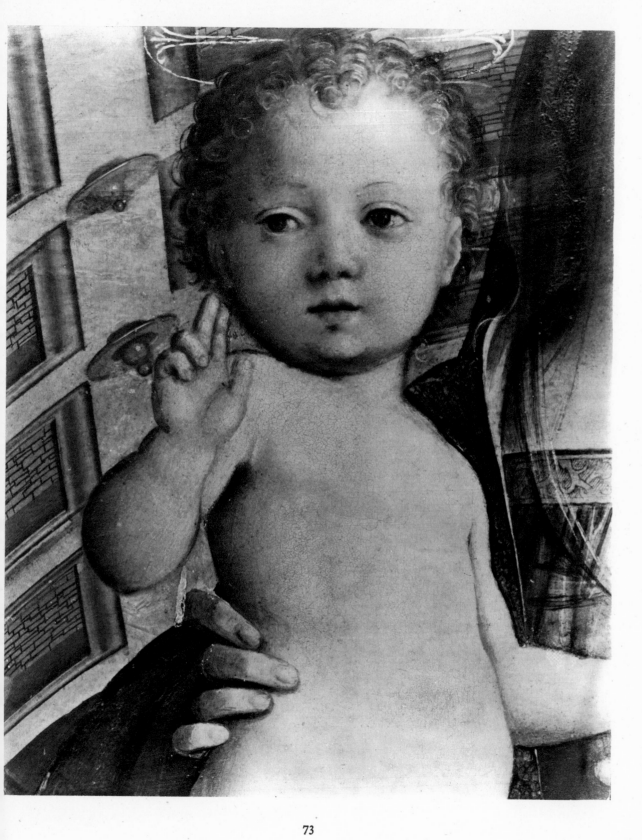

73

THE
FLIGHT INTO EGYPT

FLIGHT INTO EGYPT (Detail) *Museum of San Marco, Florence*

FRA ANGELICO? (1387–1445) *Florentine*

The plate reproduces a detail from one of thirty-five scenes, divided into four panels, that decorated a great cupboard, ordered, it is thought, by Cosimo de' Medici for the Santissima Annunziata, a church of which he became patron in 1448.

Only one panel, of six scenes from the Annunciation to the Flight into Egypt, belongs directly to Angelico. Of work attributed to Angelico some is entirely from his hand, some is from his hand in collaboration with assistants, and some is carried out by pupils and assistants in accordance with his directions. *The Flight into Egypt* itself has been thought by some scholars of eminence, as by Berenson and Van Marle, to belong to the first or second category; others ascribe it, on stylistic grounds, to the third and observe that Angelico's presence in Rome from 1445 to 1449 (in which year he was elected Prior of the Fiesole Convent) must have prevented his personally executing any of these scenes. The argument is, however, not conclusive, and it may well be that the detail here reproduced is in fact from the hand of the Master. It is at least worthy of him.

Text

THEY WARNED OUR LADY

From *Our Lord and Our Lady* by Hilaire Belloc.

IN ORDER TO ARRIVE THERE

From T. S. Eliot's *East Coker*, 1940. Compare St John of the Cross, *The Ascent of Mount Carmel*, bk. I, ch. 14, *ad finem*.

I longe for love of man my brother

They warned our Lady for the Child
　　That was our Blessed Lord,
And she took him into the desert wild,
　　Over the camel's ford.

And a long song she sang to him
　　And a short story told:
And she wrapped him in a woollen cloak
　　To keep him from the cold.

But when our Lord was grown a man
　　The Rich they dragged him down,
And they crucified him in Golgotha,
　　Out and beyond the town.

They crucified him on Calvary,
　　Upon an April day;
And because he had been her little Son
　　She followed him all the way.

In order to arrive there,
To arrive where you are, to get from where you are not,
　　You must go by a way wherein there is no ecstasy.
In order to arrive at what you do not know
　　You must go by a way which is the way of ignorance.
In order to possess what you do not possess
　　You must go by the way of dispossession.
In order to arrive at what you are not
　　You must go through the way in which you are not.
And what you do not know is the only thing you know
And what you own is what you do not own
And where you are is where you are not.

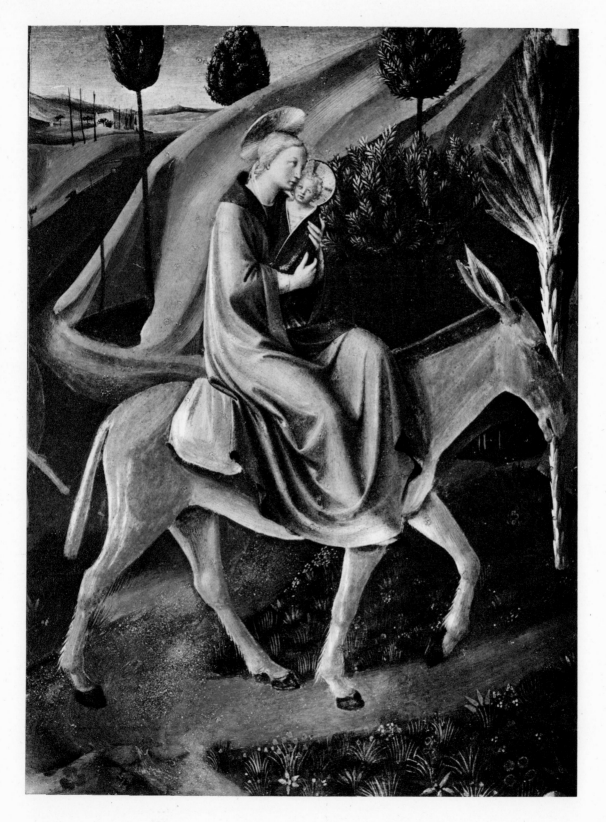

THE REST
ON THE FLIGHT INTO EGYPT

THE REST ON THE FLIGHT INTO EGYPT
 National Gallery of Art, Washington, Mellon Collection
GERARD DAVID (c. 1460–1523) *Flemish*

Unknown as a subject for painting until the 16th century, the *Flight into Egypt* quickly became one of very great popularity. It is a favourite theme of David's; there are several versions painted by himself and many contemporary copies and near-replicas.

The motif of the Virgin's wicker-basket recurs throughout the 16th century, as in the work of Patinir and Jan Brueghel, and St Joseph's beating trees is said to be derived from Flemish illuminated MSS.

The eucharistic symbolism of the Christ Child with the grapes is to be expected, perhaps, in the work of this vitally reverential artist.

The picture was painted some time after 1509.

Text

JOSEPH AND MARY WALKED

Verses taken from the *Cherry Tree Carol*, one of the most popular of old English carols, ascribed to the 16th century. This extract omits, of course, all that part of the carol that tells of St Joseph's doubts about our Lady and his consequent unkindness to her. The theme of his ungraciousness seems to have been a popular one at the time, and is perhaps to be traced in some painting.

I am treulove that fals was never

★

Joseph and Mary walked
 Through an orchard good,
Where was cherries and berries
 So red as any blood.

O then bespoke Mary,
 With words so meek and mild,
' Pluck me one cherry, Joseph,
 For I am with child.'

O then bespoke the baby
 Within his mother's womb—
' Bow down then the tallest tree
 For my mother to have some.'

Then Mary plucked a cherry,
 As red as any blood;
Then Mary she went homewards
 All with her heavy load.

As Joseph was a-walking,
 He heard an angel sing:
' This night there shall be born
 On earth our heavenly king.'

Then Mary took her young son,
 And sat him on her knee:
Saying, ' My dear son, tell me,
 Tell how this world shall be.'

' O I shall be as dead, mother,
 As stones are in the wall;
O the stones in the streets, mother
 Shall sorrow for me all.

' On Easter-day, dear mother,
 My rising up shall be;
O the sun and the moon, mother,
 Shall both arise with me.'

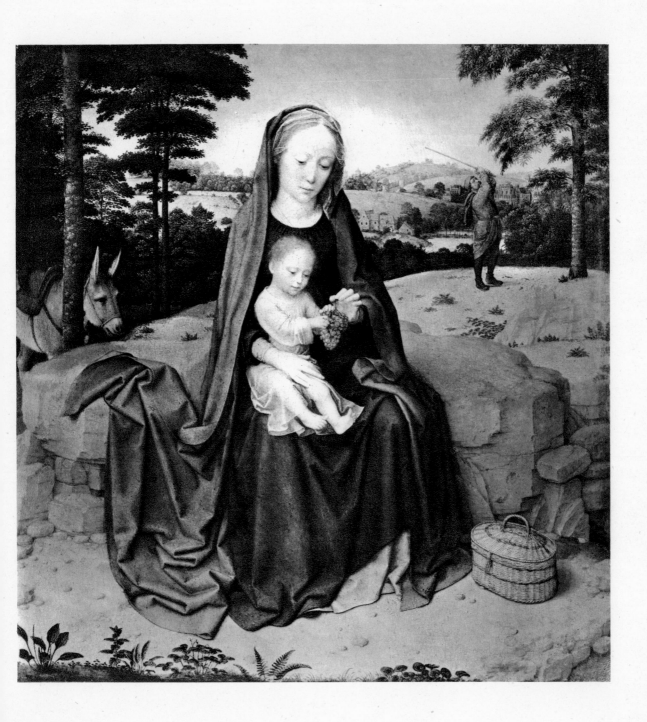

MARY AND JESUS

THE VIRGIN AND CHILD *National Gallery, London*
ASCRIBED TO HANS MEMLING (*active 1465–94*) *Flemish*

In 1465 Memling's name appears on the register of the burghers of Bruges, and in Bruges he worked and died. He was much influenced by the work of Rogier van der Weyden and in his own painting used a number of his compositions. The comparison of the atmosphere of Gerard David's pictures with that of *The Imitation of Christ* that I quoted from Sir Martin Conway's *The Van Eycks and their Followers* (see note on page 59) is possibly more apposite to Memling. And, as Sir Martin says, "David's nature seems to have been a deeper one than Memling's. There is much in common in the spirit of their art, but Memling, for all his dexterous and pleasant handling, is more superficial, more like a man who adapts himself, easily and naturally enough, yet still adapts himself, to the taste of the little society for whom he worked."

The picture here reproduced is the right wing of a diptych and the features have all been repainted to varying degrees. "The picture underneath is possibly by Memling," an expert has said, "but no certain attribution can be made."

Text

THIS ENDRIS NIGHT
A lullaby song of the early 15th century. The text is that printed by Chambers and Sidgwick, *Early English Lyrics*.

This endris night: the other night; *ever among*: from time to time; *brid*: bird; *pay*: contentment; *hill*: protect.

83

Man, why art thou unkind to me?
What woldest thou I did for thee more?

★

This endris night I saw a sight,
 A stare as bright as day;
And ever among a maiden song,
 ' Lullay, by by, Lullay.'

This lovely lady sat and song,
 And to her child con say,
' My sone, my broder, my fader dere,
 Why liest thou thus in hay?
My swete brid, thus it is betid,
 Thogh thou be king veray;
But nevertheles I will not cese
 To sing, By by, lullay.'

' Mary moder, I am thy child,
 Thogh I be laid in stall;
Lordes and dukes shall worsship me
 And so shall kinges all.
Ye shall well see that kinges three
Shall come the twelfthe day.
For this behest yeve me thy brest,
 And sing, By by, lullay.'

' Now tell me, swete son, I thee pray,
 Thou art me leve and dere,
How shuld I kepe thee to thy pay
 And make thee glad of chere?
For all thy will I wold fullfill,
 Thou weteste full well in fay;
And for all this I will thee kiss,
 And sing, By by, lullay.'

' My dere moder, whan time it be,
 Thou take me up on loft,
And sette me upon thy knee,
 And handell me full soft;
And in thy arme thou hill me warme,
 And kepe night and day;
If that I wepe, and may not slepe,
 Thou sing, By by, lullay.'

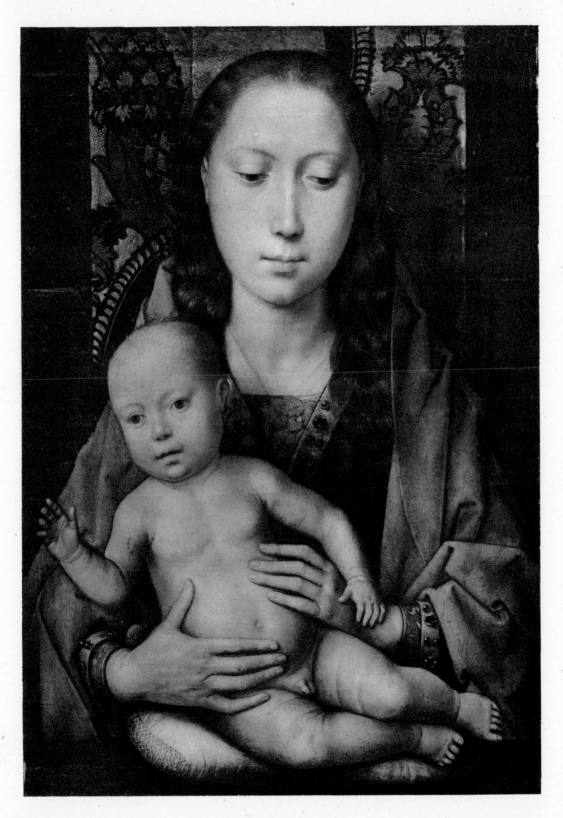

THE HOLY FAMILY

THE REST ON THE FLIGHT INTO EGYPT

National Gallery, London

STUDIO OF THE MASTER OF THE FEMALE HALF-LENGTHS *Early Netherlandish*

The Master of the Female Half-lengths is the name given to the author, or rather the production overseer, of a large group of works. This studio, according to Mr. Martin Davies, was perhaps at work in Antwerp, although the style is related to that of Ambrose Benson, who worked in Bruges. None of the paintings are dated, but the school was active in the second quarter of the 16th century.

Text

FLESH AND FLEECE

From *The May Magnificat* by Gerard Manley Hopkins, written at Stony-hurst in May 1878; " a Maypiece," he wrote to Bridges, " in which I see little good but the freedom of the rhythm." Hopkins is presumably here working out the concept of Mary as the second Eve, the " mother of all the living."

 bugle blue: blue that has the clarity and purity of a bugle note; it is a simple instance of synaesthesia—as when Hopkins writes in his diary of a " bright crabapple tingling in the wind " or of " the orange of the peeling of Mitton bells."

Mary is quene of alle thinge
And her sone a lovely kinge

★

Flesh and fleece, fur and feather,
Grass and greenworld all together;
 Star-eyed strawberry-breasted
 Throstle above her nested

Cluster of bugle blue eggs thin
Forms and warms the life within;
 And bird and blossom swell
 In sod or sheath or shell.

All things rising, all things sizing
Mary sees, sympathising
 With that world of good,
 Nature's motherhood.

Their magnifying of each its kind
With delight calls to mind
 How she did in her stored
 Magnify the Lord.

Well but there was more than this:
Spring's universal bliss
 Much, had much to say
 To offering Mary May.

When drop-of-blood-and-foam-dapple
Bloom lights the orchard-apple
 And thicket and thorp are merry
 With silver-surfèd cherry

And azuring-over greybell makes
Wood banks and brakes wash wet like lakes
 And magic cuckoocall
 Caps, clears, and clinches all——

This ecstasy all through mothering earth
Tells Mary her mirth till Christ's birth
 To remember and exultation
 In God who was her salvation.

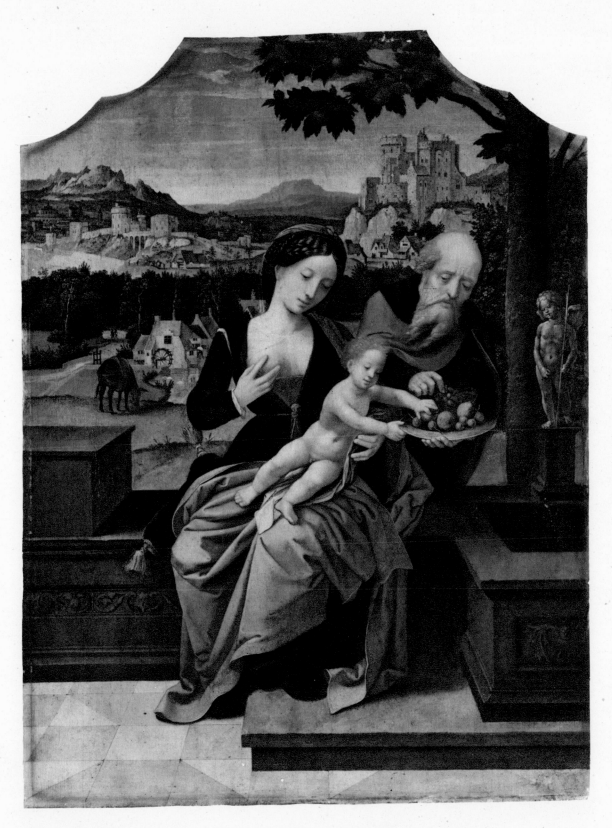

THE
VIRGIN AND THE CHILD

THE VIRGIN AND CHILD *Brera Gallery, Milan*

Giovanni Bellini (c. 1430–1516) *Venetian*

By 1480 Giovanni Bellini was, by general agreement, the Master of the Venetian School. Indeed, no other school of painting is so much one man's creation.

The subject of the Virgin and Child was the central one of Bellini's work, whether it was the theme of his elaborate altar-pieces or of simple pictures for family devotion. But he is never monotonous. "The richness of his invention," as Roger Fry wrote, "is shown by the perfect harmony of the particular feeling expressed by the mother with the pose and expression of the child".

This painting came from the Palace of the Doges.

Text

THE HOLLY AND THE IVY

A 16th century carol. (It is possible that this tender Christian carol is made from a piece of symbolism that is, in origin, pagan.)

I AM TRUE LOVE

A stanza from *In a valey of this restles minde*, a 14th century lyric of which there are several versions. This text, from a Lambeth MS, written about 1430, is the text as it is printed by Chambers and Sidgwick, *Early English Lyrics*. (In the third line *I* is sometimes printed instead of *we*, a needless emendation, if emendation it is, since *we* is theologically more sensitive.) *Amore langueo*, "I languysh for lufe" (Richard Rolle), is a refrain from *The Song of Songs*. It may be that this lyric is modelled on an Appeal of the Virgin, with the same refrain, *In a tabernacle of a toure* (Carlton Brown, *Religious Lyrics of the Fourteenth Century*, No. 132), that is also found in the Lambeth MS and in other and better versions. The number of versions, and of altered versions, of this poem are some indication of its appeal.

For he is born to ware the purpell hue

★

The holly and the ivy,
When they are both full grown,
Of all the trees that are in the wood,
The holly bears the crown:

The rising of the sun
And the running of the deer,
The playing of the merry organ,
Sweet singing in the choir.

The holly bears a blossom,
As white as the lily flower,
And Mary bore sweet Jesus Christ
To be our sweet Saviour:

The holly bears a berry,
As red as any blood,
And Mary bore sweet Jesus Christ
To do poor sinners good:

The holly bears a prickle,
As sharp as any thorn,
And Mary bore sweet Jesus Christ
On Christmas day in the morn:

The holly bears a bark,
As bitter as any gall,
And Mary bore sweet Jesus Christ
For to redeem us all:

The holly and the ivy,
When they are both full grown,
Of all the trees that are in the wood,
The holly bears the crown:

★

I am true love that fals was nevere;
My sister, mannes soule, I loved her thus;
Because we wolde in no wise discevere,
I lefte my kingdom glorious.
I purveide for her a paleis precious;
Sche fleith, I folowe, I soughte her so;
I suffrede this peine piteous,
Quia amore langueo.

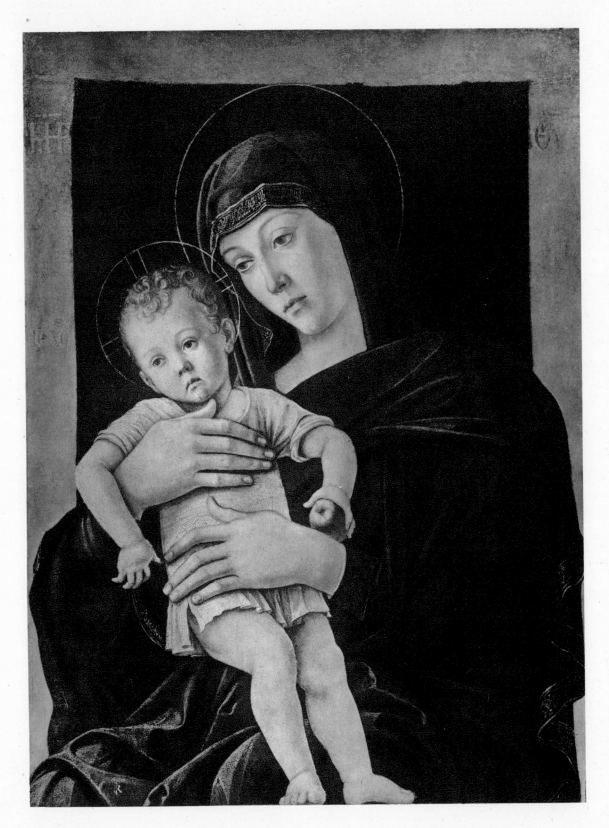

93

ACKNOWLEDGEMENTS

The author makes grateful acknowledgement to the following for permission to reproduce the illustrations and reprint the poems and extracts in this book:

The Misses Frere and Mrs. Woodall and the trustees of the National Gallery for Plate I; the trustees of the National Gallery for Plates II-IV, VI-XIV, XVI, and XIX-XX; the trustees of the National Gallery of Art, Washington, for Plates V, XV, and XVIII; Mr. F. W. Mansell for Plates XVII and XXI; Mr. Hilaire Belloc, Messrs. Gerald Duckworth & Co. and Messrs. Sheed & Ward, Inc. for *Our Lord and Our Lady* from SONNETS AND VERSE; Mr. Gerald Bullett for his *Carol*; The Cambridge University Press for an extract from A. R. Waller's edition of Cowley's *Davideis*; the Clarendon Press for an extract from the Prioress's Prayer, taken from W. W. Skeat's edition of THE COMPLETE WORKS OF CHAUCER, and for an extract from Professor L. C. Martin's edition of Crashaw's POEMS, ENGLISH, LATIN AND GREEK, *On the Blessed Virgin's Bashfulness*; Mr. T. S. Eliot, Messrs. Faber & Faber and and Messrs. Harcourt, Brace & Co., Inc. for extracts from *The Dry Salvages*, *A Song for Simeon* and *East Coker*; the Trustees of the Hardy Estate, Messrs. Macmillan & Co. and The Macmillan Company for *The Oxen* from Thomas Hardy's COLLECTED POEMS; Mr. Christopher Hassall and Messrs. Heinemann & Co. for an extract from CHRIST'S COMET; Mr. John Hayward for an extract from *The Annunciation* in the Nonesuch Edition of Donne's DIVINE POEMS; Messrs. Novello & Co. for *The Holly and the Ivy*; the Oxford University Press for Gerard Manley Hopkins' translation of *Jesu Dulcis Memoria*, and for *The Cherry Tree Carol* from THE OXFORD BOOK OF CAROLS; Professor Allison Peers, Messrs. Burns Oates & Washbourne and The Newman Press for part of his translation of *The Dark Night* by St. John of the Cross; Mr. F. T. Prince and the Editor of THE MONTH for *The Annunciation*; Messrs. Sidgwick & Jackson, Ltd. for *I Sing of a Maiden*, *In a Valey of this Restless Mind*, *The Shepard upon a Hill*, *This Endrys Night* and *When Christ was Born*, from Chambers & Sidgwick's EARLY ENGLISH LYRICS; His Eminence the Cardinal Archbishop of Westminster, Messrs. Burns Oates & Washbourne, Ltd. and Messrs. Sheed & Ward, Inc. for an extract from the Book of Proverbs, from THE BIBLE translated by Monsignor Ronald Knox.